LIFE
with Dogs

LIFE
with Dogs

CATCHING 40 WINKS
There are few things more comforting than the quiet presence
of a furry companion during an impromptu afternoon nap.
Photograph by Kevin Taylor

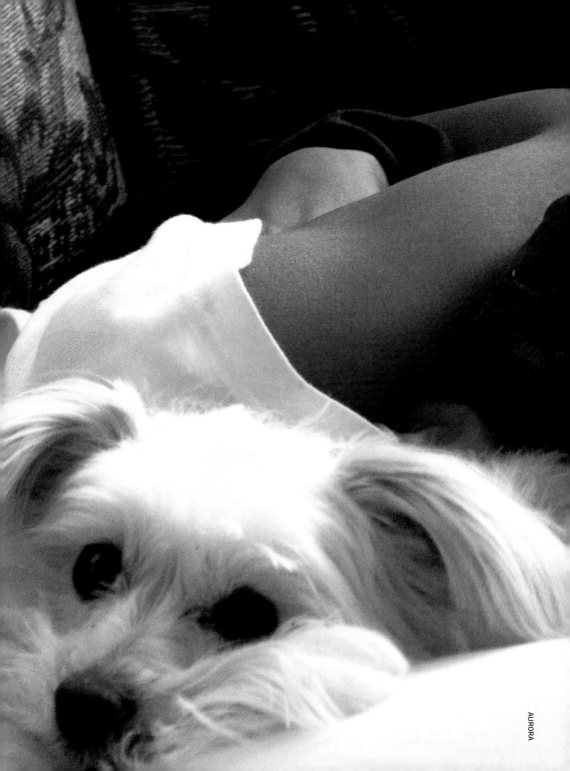

LIFE Books

EDITOR Robert Sullivan
DIRECTOR OF PHOTOGRAPHY
Barbara Baker Burrows
DEPUTY PICTURE EDITOR
Christina Lieberman
CREATIVE DIRECTOR Michael Roseman
COPY CHIEF Barbara Gogan

PRESIDENT Andrew Blau
BUSINESS MANAGER Roger Adler
BUSINESS DEVELOPMENT MANAGER
Jeff Burak

EDITORIAL OPERATIONS
Richard K. Prue (Director), Brian Fellows (Manager),
Keith Aurelio, Charlotte Coco, John Goodman,
Kevin Hart, Norma Jones, Mert Kerimoglu, Rosalie Khan,
Patricia Koh, Marco Lau, Brian Mai, Po Fung Ng,
Lorenzo Pace, Rudi Papiri, Robert Pizaro, Barry Pribula,
Clara Renauro, Donald Schaedtler, Hia Tan,
Vaune Trachtman, David Weiner

TIME INC. HOME ENTERTAINMENT

PUBLISHER Richard Fraiman
GENERAL MANAGER Steven Sandonato
EXECUTIVE DIRECTOR, MARKETING SERVICES
Carol Pittard
DIRECTOR, RETAIL & SPECIAL SALES
Tom Mifsud
DIRECTOR, NEW PRODUCT DEVELOPMENT
Peter Harper
ASSISTANT DIRECTOR, BOOKAZINE MARKETING
Laura Adam
ASSISTANT DIRECTOR, BRAND MARKETING
Joy Butts
ASSOCIATE COUNSEL Helen Wan
BOOK PRODUCTION MANAGER Suzanne Janso
DESIGN & PREPRESS MANAGER
Anne-Michelle Gallero
BRAND MANAGER Shelley Rescober

SPECIAL THANKS TO
Christine Austin, Glenn Buonocore, Jim Childs,
Susan Chodakiewicz, Jacqueline Fitzgerald,
Rasanah Gross, Lauren Hall, Jennifer Jacobs,
Brynn Joyce, Robert Marasco, Amy Migliaccio,
Brooke Reger, Ilene Schreider, Adriana Tierno,
Sydney Webber, Alex Voznesenskiy, Jonathan White

COPYRIGHT 2009
TIME INC. HOME ENTERTAINMENT

PUBLISHED BY LIFE BOOKS

TIME INC.
1271 AVENUE OF THE AMERICAS
NEW YORK, NEW YORK 10020

ISBN 13: 978-1-60320-100-1
ISBN 10: 1-60320-100-9
Library of Congress Number: 2009928256

"LIFE" is a trademark of Time Inc.

We welcome your comments and suggestions about
LIFE Books. Please write to us at:
LIFE Books
Attention: Book Editors
PO Box 11016
Des Moines, IA 50336-1016

If you would like to order any of our hardcover Collector's
Edition books, please call us at 1-800-327-6388
(Monday through Friday, 7:00 a.m.–8:00 p.m.,
or Saturday, 7:00 a.m.–6:00 p.m., Central Time).

Classic images from the pages and covers of LIFE are now
available. Posters can be ordered at www.LIFEposters.com.

Fine art prints from the LIFE Picture Collection and
the LIFE Gallery of Photography can be viewed at
www.LIFEphotographs.com.

Endpaper illustration courtesy of Susan Patterson

"Dogs feel very strongly that they should always go with you in the car, in case the need should arise for them to bark violently at nothing right in your ear."

— Dave Barry, American humorist

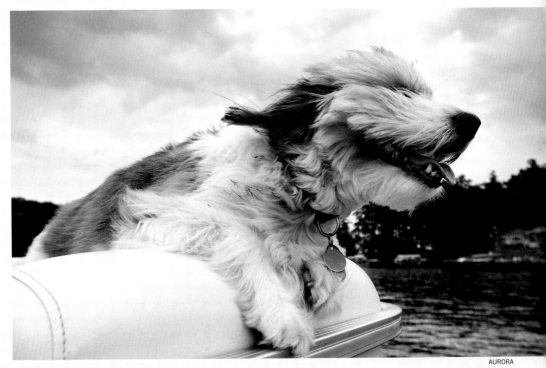

AURORA

GRINNING FROM EAR TO EAR
Claiming her spot of honor on a speedboat in southwestern Michigan, Zoe laughs with glee as she leaves all the other aquatically minded dogs in her wake.
Photograph by Jim Powell

INTRODUCTION

THERE MAY BE AS MANY AS 400 MILLION DOGS IN THE WORLD and 75 million of them live right here in the United States. Our canine friends are, to use the old phrase, as American as apple pie—something that President Harry S Truman well understood when he said, "Children and dogs are as necessary to the welfare of the country as Wall Street and the railroads."

That's a considerable responsibility to place upon a pooch, but day in and day out, dogs deliver. They keep us company and, with their antics and enthusiasm, keep us cheerful. They have, down through the decades, served as our herders, hunters, draft animals and guardians. They have guided us when we are disabled and rescued us when we are lost or injured. They have gone to war at our side.

Dogs give us companionship and affection; if you have a dog in your life, you are never truly alone. They offer their acceptance and love without reservation. Dogs improve us in ways that can be direct or subtle. By dragging us outside for walks or playtime, they help keep us healthy and remind us of our bond with nature. And as we take care of them, we learn what it means to be responsible for another life.

Our relationship with dogs is long-standing and has evolved over time. People and dogs first got acquainted thousands of years ago when the canines were still wolves. They were the first animals we domesticated, and, reciprocally, it seems either a happy accident or a miracle of nature that these creatures welcomed us as part of their tribe—invited us into their life as much as we invited them into ours.

This book is a celebration of that relationship. It is brimming with compelling, eloquent, inspiring and delightful photographs. In these pages you will meet the world's tallest dog as well as its smallest. There are dogs that work for a living and dogs that kick back and take things easy. We found a dog that rescues cats and a dog that loves to surf. There are touching stories herein: a stray dog who developed an unusual friendship with a rescued elephant, another dog that was saved after being stuck on a mountain ledge for more than a week. There are funny stories, too, as you would expect—and many, many images that elicit the pure joy we feel when we interact with a happy dog.

This is the third in our series of books that began with LIFE with Mother and was followed by LIFE with Father. When we considered what the next cornerstone in the family should be, the answer presented itself quickly: "man's best friend." Those of you who are already dog lovers will find photographs that resonate with your own experiences, and those who have never had the pleasure of sharing life with a dog might be inspired to consider it. We hope so.

We hope, too, that you enjoy this book half as much as we enjoyed creating it. We got to spend time each day with dozens upon dozens of dogs. What could be better?

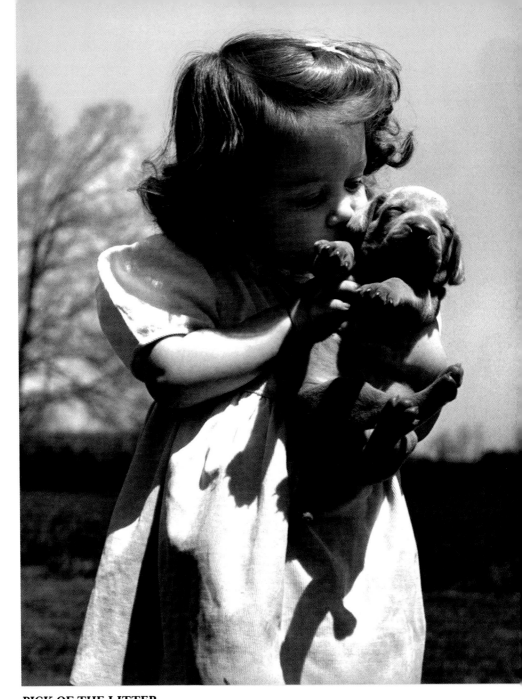

PICK OF THE LITTER
Three-year-old Christina smooches a Weimaraner puppy that she has claimed for her own.
Photograph by Bernard Hoffman

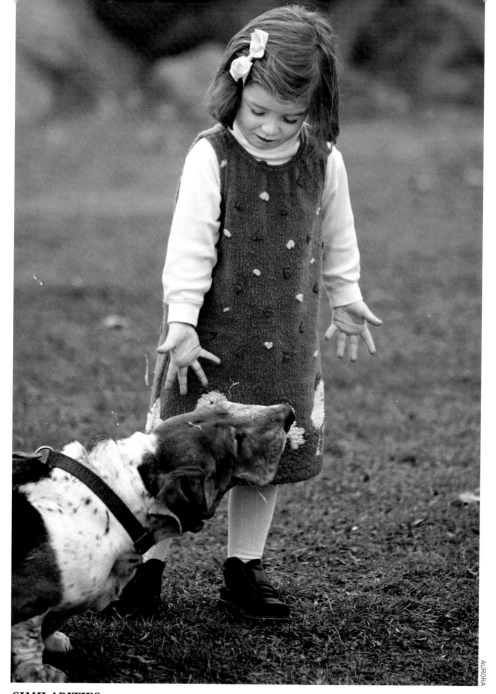

SIMILARITIES
In Marblehead, Massachusetts, redheaded Nora Jasaitus meets a Basset Hound of like hue.
Photograph by Laurie Swope

> "Inside every Newfoundland, Boxer, Elkhound and Great Dane is a puppy longing to climb on to your lap."
>
> — Helen Thomson, Australian author

CONTRASTS
A two-year-old boy in Grass Valley, California, stands beside the Great Dane Gibson, reckoned to be the world's tallest dog by the Guinness Book of World Records.
Photograph by Deanne Fitzmaurice

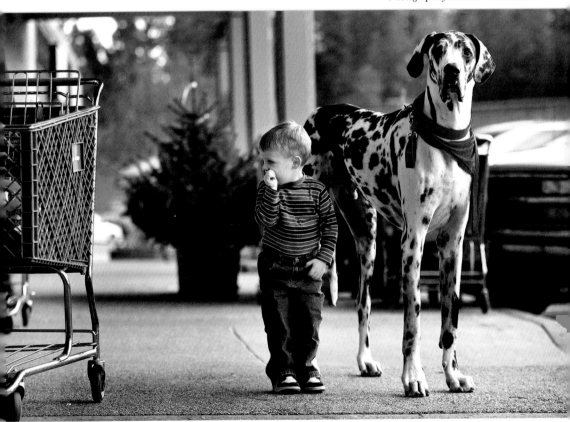

HOME ON THE RANGE
Their dogs lead the way for these cowboys in Oregon.
Photograph by Konrad Wothe

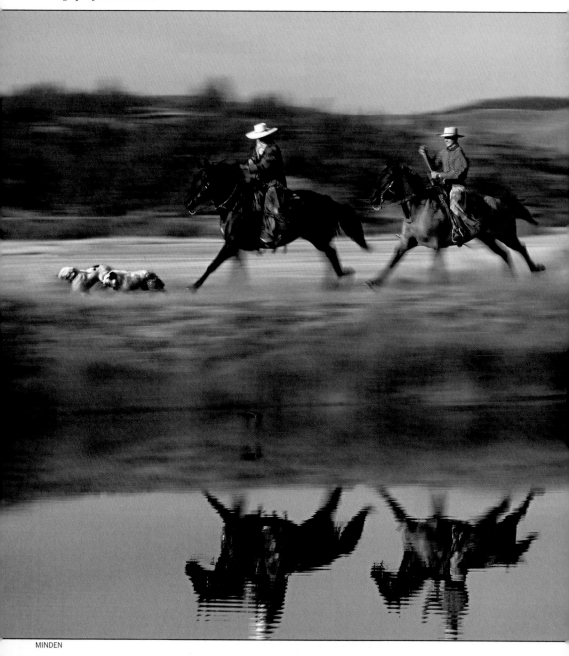

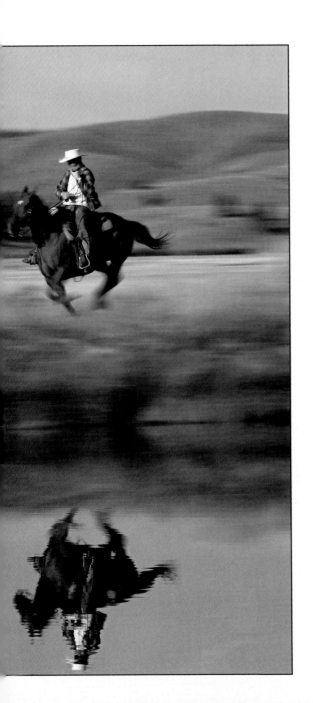

"No philosophers so thoroughly comprehend us as dogs and horses.**"**

— Herman Melville,
American novelist

"An animal's eyes have the power to speak a great language."
— Martin Buber, Jewish philosopher

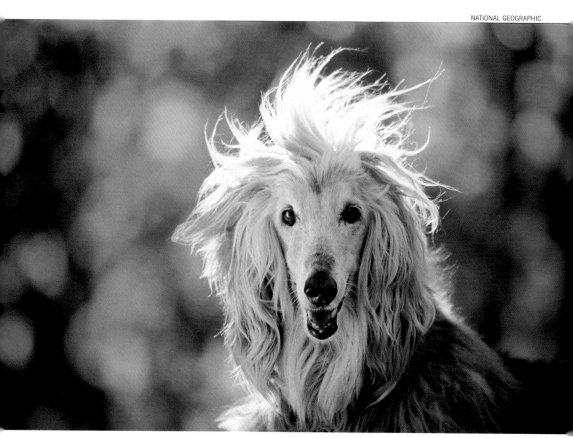

BLOWIN' IN THE WIND
Afghans don't need kaftans to look well-dressed.
Photograph by Joel Sartore

BEHIND BLUE EYES
A Weimaraner ponders the world from the perspective of his fence.
Photograph by Mark Raycroft

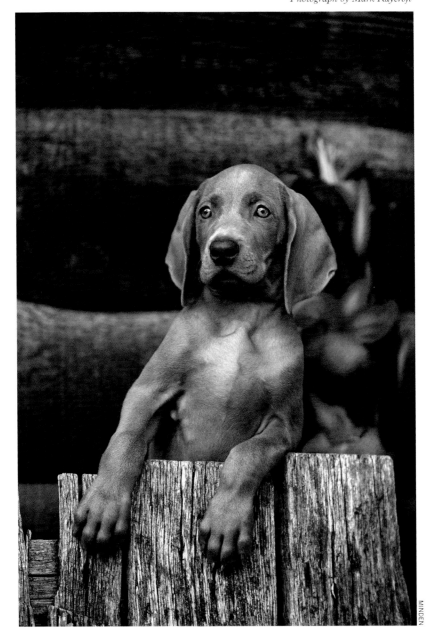

"A dog has the soul of a philosopher."
— Plato, Greek philosopher

PRACTICE MAKES PERFECT
A rescue dog follows its trainer into the water
during a training session in Pisogne, Italy.
Photograph by Alessandro Garofalo

INSTANT FRIENDS
During security operations in Iraq's Diyala province, U.S. Army Sergeant
Marcus Mayward enjoys a tender lick from a military dog trained to sniff out explosives.
Photograph by Andrea Comas

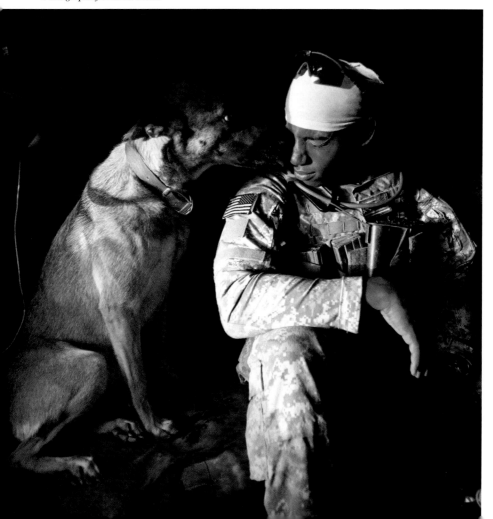

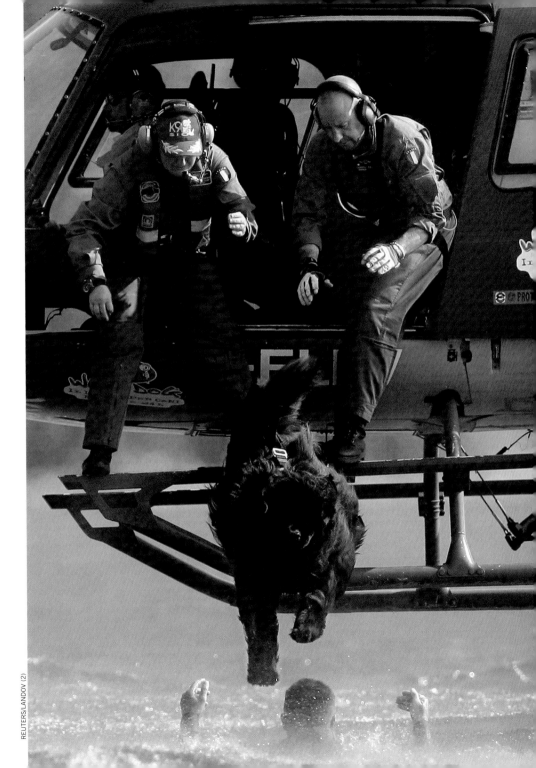

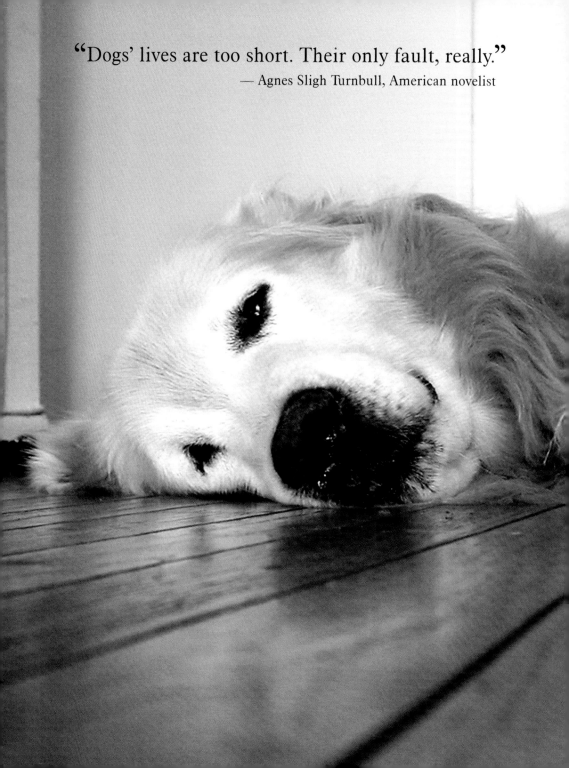

"Dogs' lives are too short. Their only fault, really."

— Agnes Sligh Turnbull, American novelist

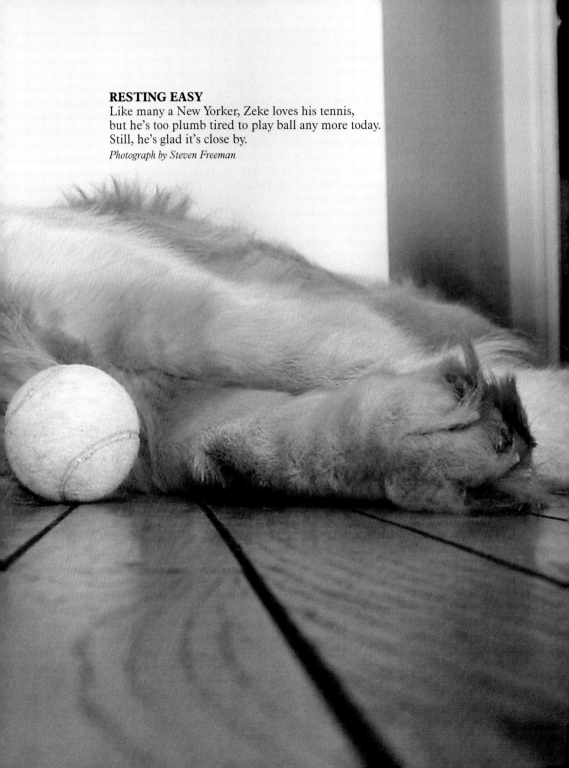

RESTING EASY
Like many a New Yorker, Zeke loves his tennis,
but he's too plumb tired to play ball any more today.
Still, he's glad it's close by.
Photograph by Steven Freeman

"A good dog is one of the best things of all to be."

— Dean Koontz, American author

AURORA

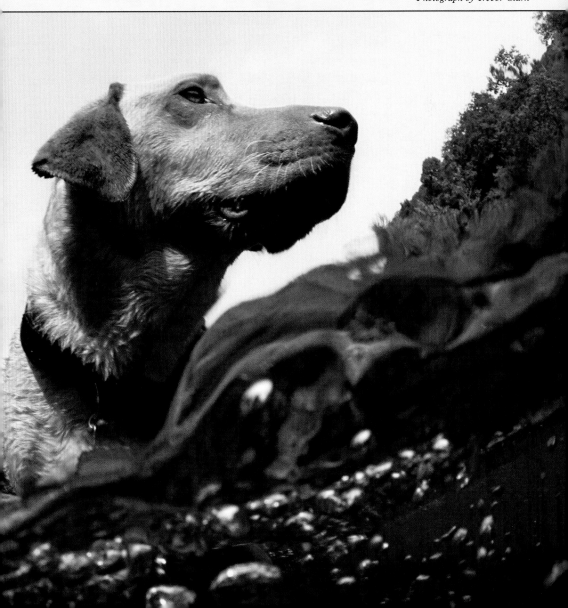

IN HIS ELEMENT
Aptly named Flow jumps into the New River near
Fayetteville, West Virginia, while Jeremy Laucks boards his squirt boat.
Photograph by Trevor Clark

ONE GOOD LICK...

No matter what the tabby thinks, this dog is not about to stop
until her friend is thoroughly spic-and-span.
Photograph by G K & Vikki Hart

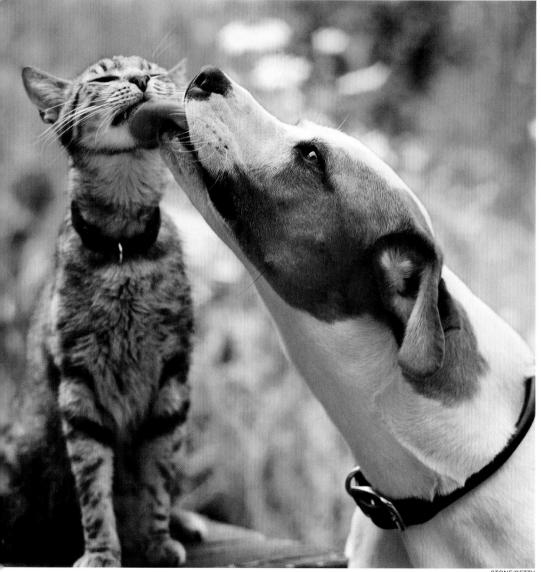

"Dogs laugh, but they laugh with their tails."

— Max Eastman, American writer

...DESERVES ANOTHER
She can't stop giggling and he can't stop licking.
They make a perfect team.
Photograph by Jim Powell

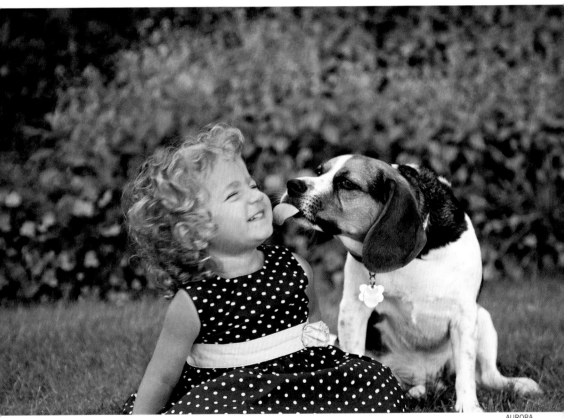

AURORA

"The dog is a gentleman;
I hope to go to his heaven,
not man's."
— Mark Twain, American novelist

HIS BEST EEYORE IMITATION
This Basset Hound puppy can't
possibly be as sad as he looks.
Photograph by Mark Raycroft

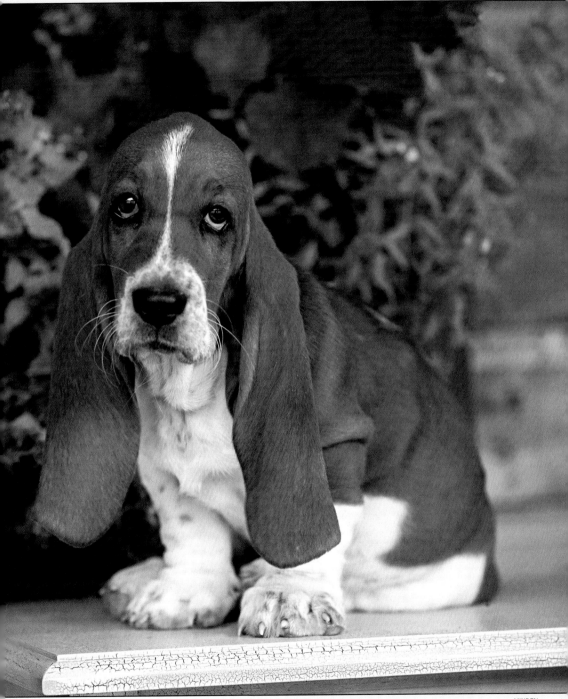

"Among God's creatures two, the dog and the guitar, have taken all the sizes and all the shapes, in order not to be separated from the man."
— Andrés Segovia, Spanish guitarist

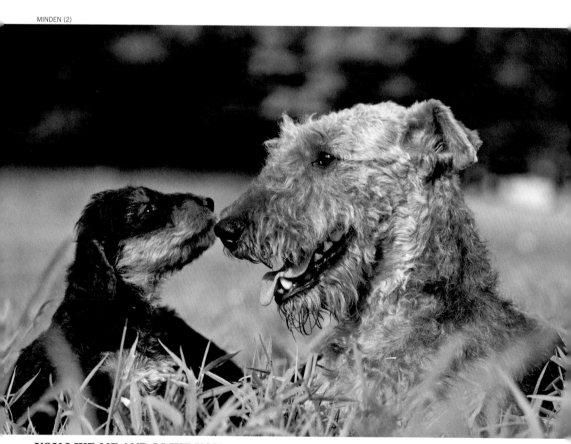

YOU LIKE ME AND I LIKE YOU
A mother and pup Airedale enjoy the simple pleasures of a grassy field in Japan.
Photograph by Mitsuaki Iwago

CAUTION, WRINKLES BELOW

Like watchful guardians, these two Shar Pei puppies are monitoring the situation.

Photograph by Mitsuaki Iwago

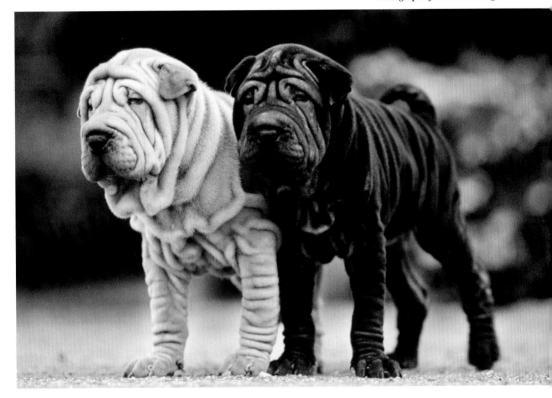

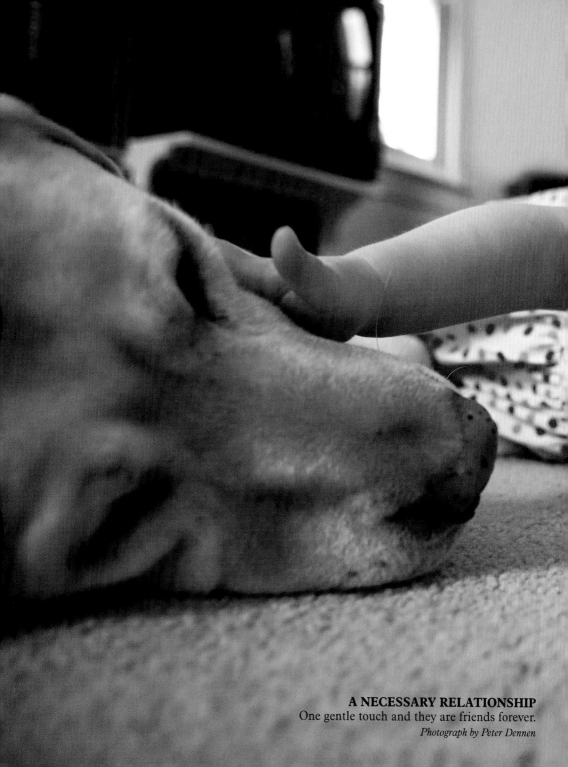

A NECESSARY RELATIONSHIP
One gentle touch and they are friends forever.
Photograph by Peter Dennen

"I think dogs are the most amazing creatures; they give unconditional love. For me they are the role model for being alive."
— Gilda Radner, American comedienne

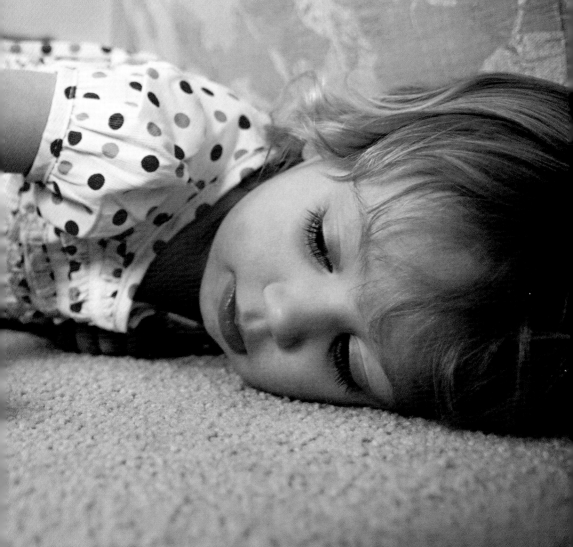

"In order to really enjoy a dog, one doesn't merely try to train him to be semihuman. The point of it is to open oneself to the possibility of becoming partly a dog."

— Edward Hoagland, American author

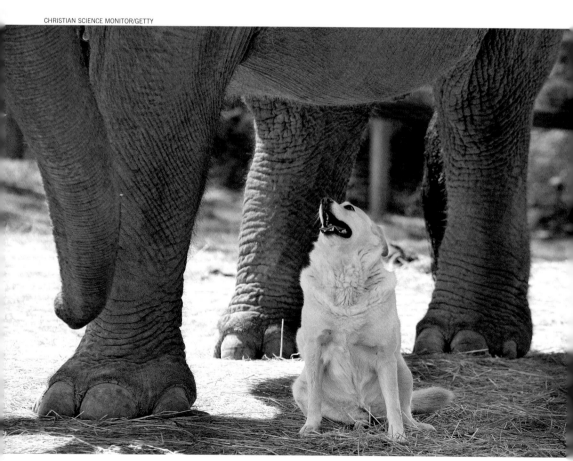

CONSTANT COMPANIONS

A stray dog named Bella and her best friend, Tarra, spend some quality time together at The Elephant Sanctuary, a refuge center for abused elephants in Hohenwald, Tennessee.

Photograph by Melanie Stetson Freeman

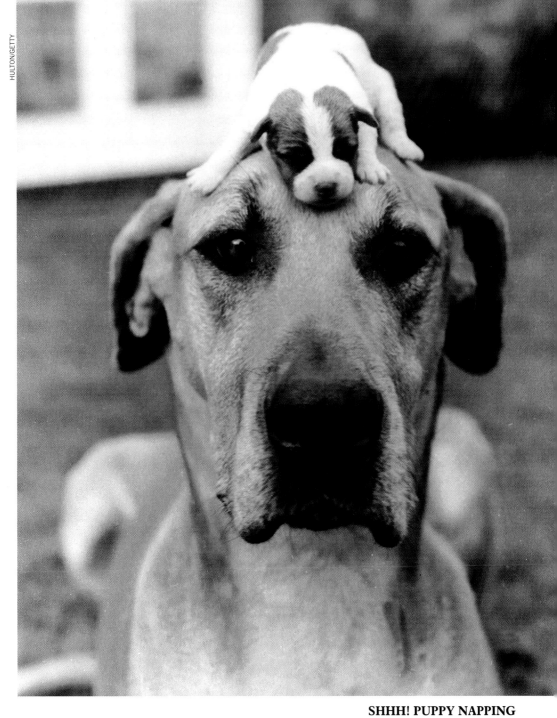

SHHH! PUPPY NAPPING
Great dogs sometimes have lesser dogs on their minds.

> **"**There is no faith which has never yet been broken, except that of a truly faithful dog.**"**
>
> — Konrad Lorenz, Austrian zoologist

IT'S A DOG'S LIFE

With as much dignity as possible, a Maltese endures a fancy bath replete with mud from the Red Sea in a Tokyo beauty salon dedicated to canine perfection.

Photograph by Chris Steele-Perkins

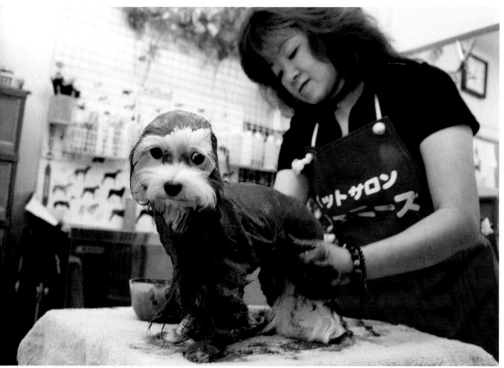

MAGNUM

MEALS ON PAWS
Knowing that his mission is to deliver good food to his owner, a guide dog visits
a delicatessen in Reims, a city in the Champagne-Ardenne region of France.

Photograph by Thierry Prat

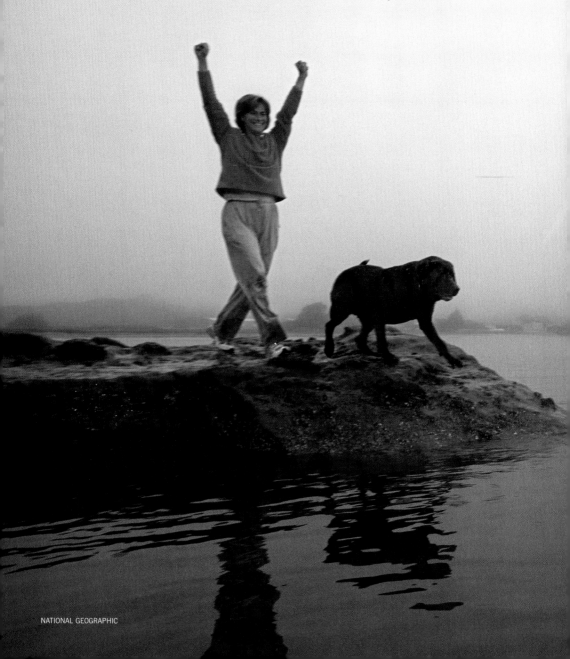

"If you can look at a dog and not feel vicarious excitement and affection, you must be a cat."

— Anonymous

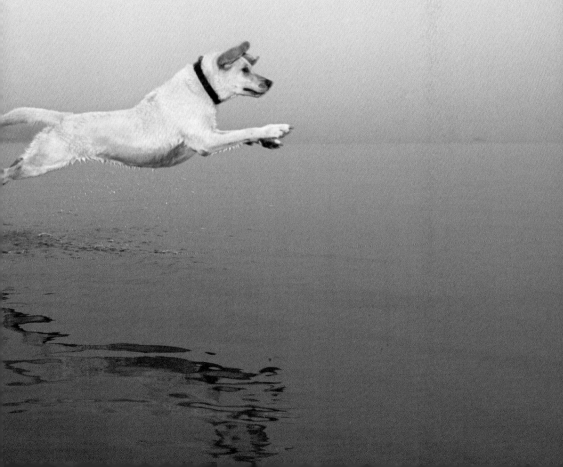

ONE GOOD LEAP DESERVES ANOTHER
With a determined expression, Kona takes to
the air above the waters of California's Half Moon Bay
while Robin Toft cheers him on and fellow Labrador
Retriever Chip gets ready to follow his lead.
Photograph by Roy Toft

"My little dog—a heartbeat at my feet."
— Edith Wharton, American novelist

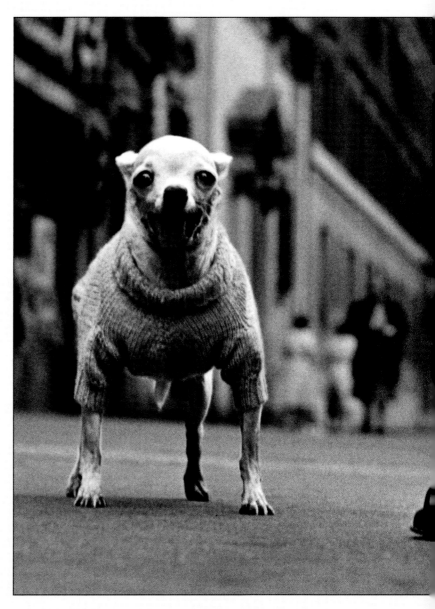

URBAN WALKABOUT
His mistress's feet have signaled a brief paws
in the action for this New York City Chihuahua.
Photograph by Elliott Erwitt

SHOW-OFF
Apparently, this Doberman Pinscher will do almost anything to stand out from all
the other dogs at the Wilsonia Kennels in Rushville, Indiana.
Photograph by Willard Culver

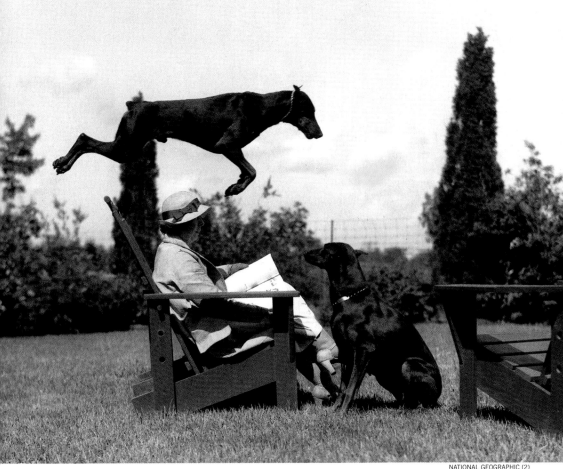

"There is no psychiatrist in the world like a puppy licking your face."

— Ben Williams, American journalist

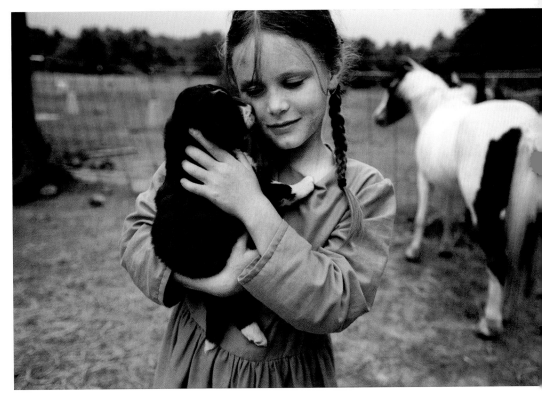

BACK TO BASICS
Even though there are plenty of chores to do on this farm in the Ozarks, one young Mennonite girl and her puppy can still find time for the simple pleasures.
Photograph by Randy Olson

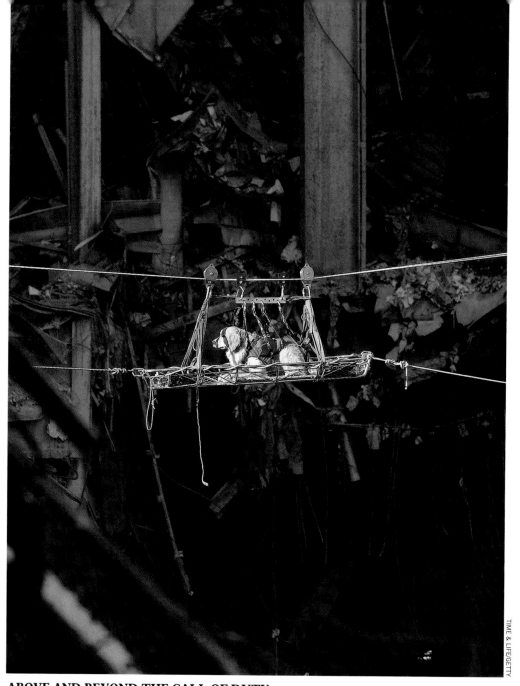

ABOVE AND BEYOND THE CALL OF DUTY
After a difficult day of work, a rescue dog patiently waits as he is transported
out of the danger zone at New York City's World Trade Center.
Photograph by Mai

"You think dogs will not be in heaven? I tell you, they will be there long before any of us."

— Robert Louis Stevenson, Scottish author

REST FOR THE WEARY
A lifetime of service has earned Rick some tender love and care at this unusual home for retired guide dogs in Sapporo, Japan.
Photograph by Kim Kyung-Hoon

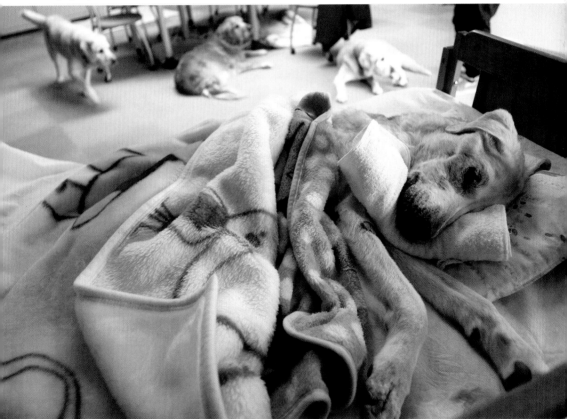

> **"If you get to thinking you're a person of some influence, try ordering somebody else's dog around."**
>
> — Will Rogers, American humorist

THE FINE ART OF BLENDING IN
While a herd of sheep hobnob on a hillside in Tuscany, Italy, near the town of Pienza, their guard dog makes a noble effort at appearing to be just one of the ruminants.
Photograph by Joel Sartore

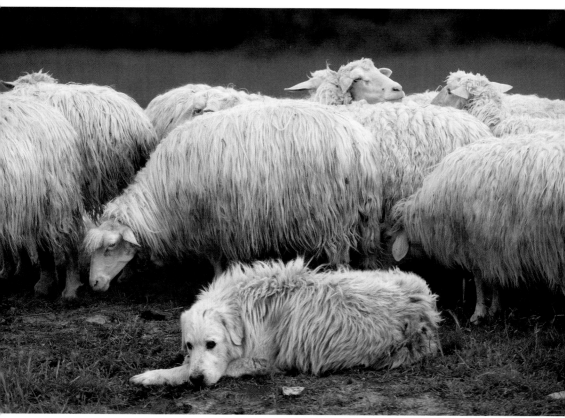

THE HIGH LONESOME
Buckaroo T. J. Symonds and his dog ride the range
together on the 1,300,000 acres of the Il Ranch in northern Nevada.
Photograph by William Albert Allard

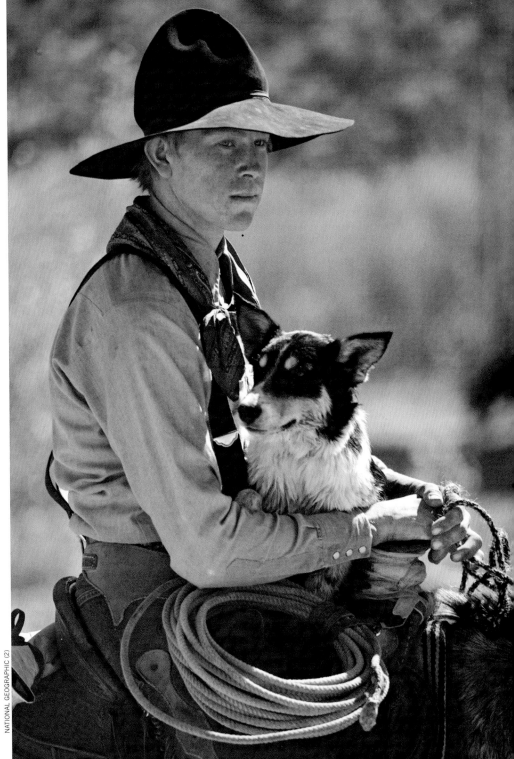

Dogs are mirrors into our own souls. Unlike children, they remain content in that role.

"I hope you're happy wherever you are."
— Errol Flynn, swashbuckling actor,
after his beloved Schnauzer, Arno, passed away

TWO AT THE HELM
Arno is Flynn's constant companion, growling during the filming of
the actor's many fight scenes, barking excitedly as soon as each scene
is done, and providing steady nautical advice when master and dog
find the time to relax together on their yacht, *Sirocco*.
Photograph by Peter Stackpole

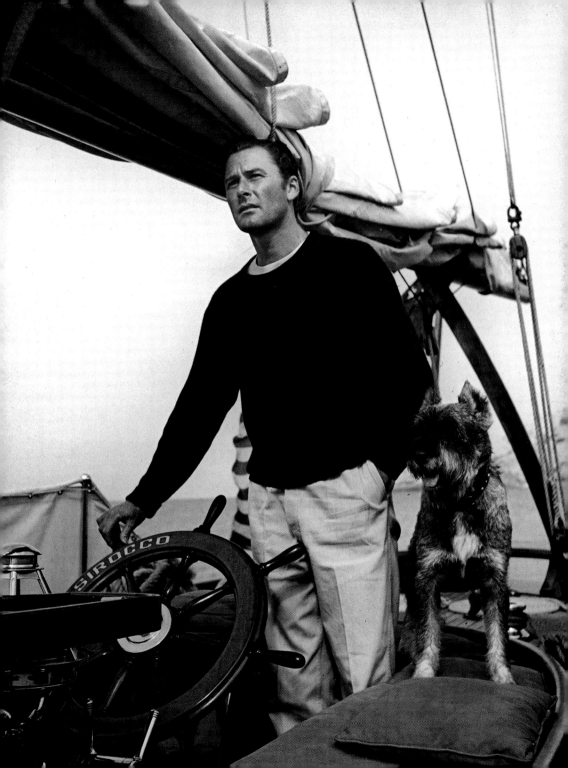

ALL SMILES
Sheryl Crow enjoys a little down time on her Tennessee farm with her very happy dogs.

Photograph by Jonathan Skow

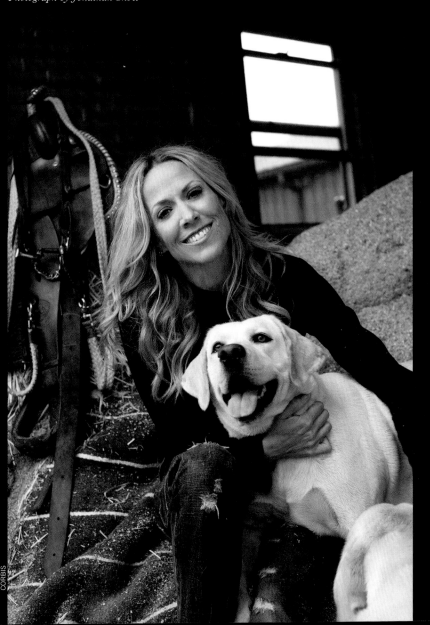

> **"**Not all dogs get to live like this, Scout.**"**
> — Sheryl Crow, American singer/songwriter

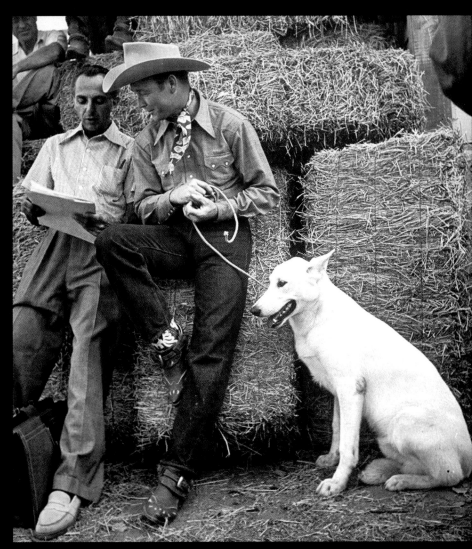

PATIENCE IS A VIRTUE

With Phantom at his side, cowboy actor Roy Rogers meets with his agent on a Republic S████ios movie lot. Rogers kept dozens of dogs throug████his career.

Photograph by Alfred Eisenstaedt

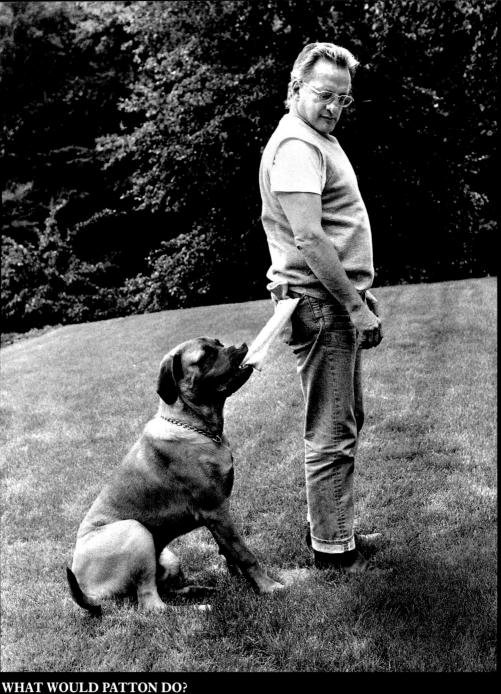

WHAT WOULD PATTON DO?
At ease on the lawn of his Greenwich, Connecticut, home, actor
George C. Scott contemplates his response to this insubordination.
Photograph by Steve Schapiro

"Our dog chases people on a bike. We've had
to take it off him."
— Winston Churchill, Prime Minister of Great Britain

MASTER AND COMMANDER
Churchill takes a break on the grounds of his country estate, Chartwell, in Kent,
and rests on a bench with Rufus, his second poodle to bear the name.
Photograph by Mark Kauffman

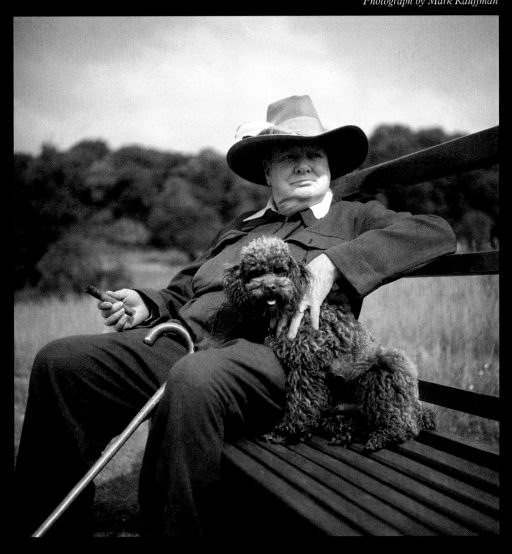

"Barbra is the kind of person who is hurt if her puppy walks past her." — Elliot Gould, American actor

FUNNY FACES
With a fitting, larger-than-life backdrop, singer and actress Barbra Streisand cradles her Toy Poodle Sadie during a 1966 cover shoot for, yes, LIFE.
Photograph by Bill Eppridge

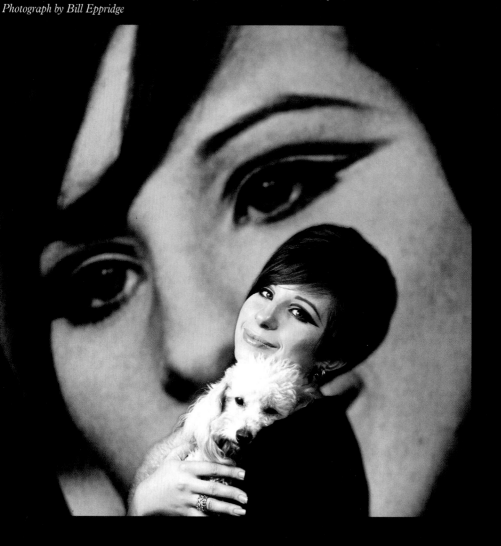

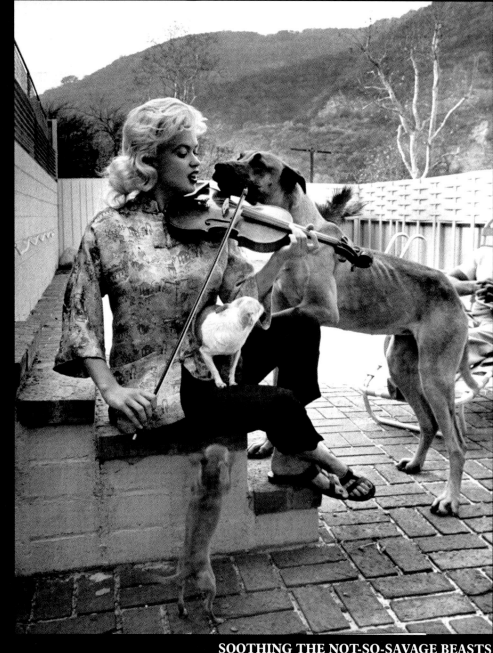

SOOTHING THE NOT-SO-SAVAGE BEASTS

With some time to spare, actress and (believe it or not!) accomplished musician Jayne Mansfield entertains her dogs on a Hollywood poolside terrace.

Photograph by Ralph Crane

"Fala accepted me after my husband's death, but I was just someone to put up with until the master should return. Many dogs eventually forget. I felt that Fala never really forgot."

— Eleanor Roosevelt, First Lady of the United States

CONSTANT COMPANIONS
President Franklin Delano Roosevelt dotes on his devoted Scottish Terrier, Fala, who accompanies the President on planes, trains and automobiles, charming various world leaders along the way.

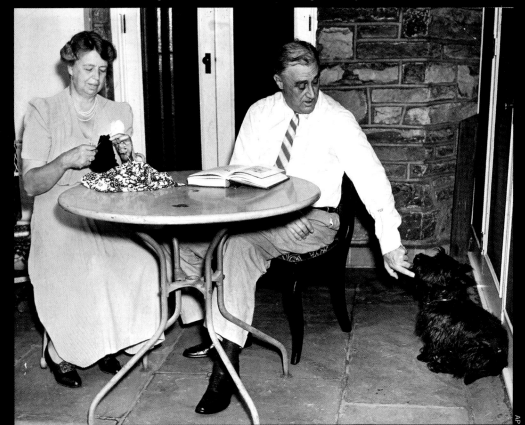

AP

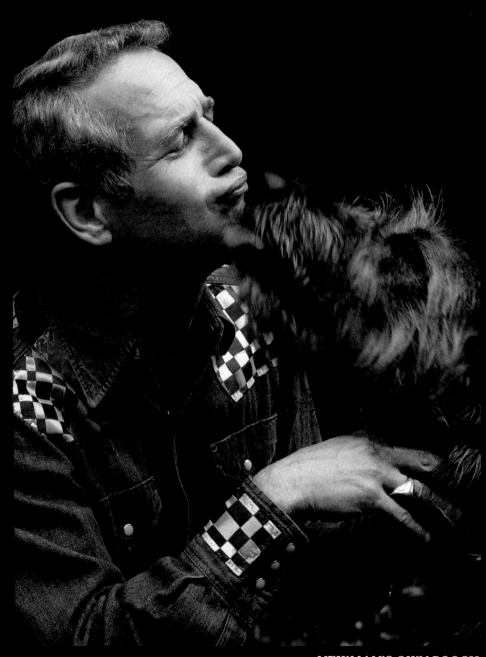

NEWMAN'S OWN POOCH
Wearing a racing flag shirt, actor Paul Newman graciously accepts
a few kisses from his dog at their Westport, Connecticut, home.
Photograph by Milton H. Greene

"We each had to spend a week out at Lassie's ranch and whoever got along best with the dog got the part."
— Tommy Rettig, child actor

QUIET ON THE SET
Two consummate professionals, who clearly get along, prepare themselves for a second take on the set of the television show *Lassie*.
Photograph by George Silk

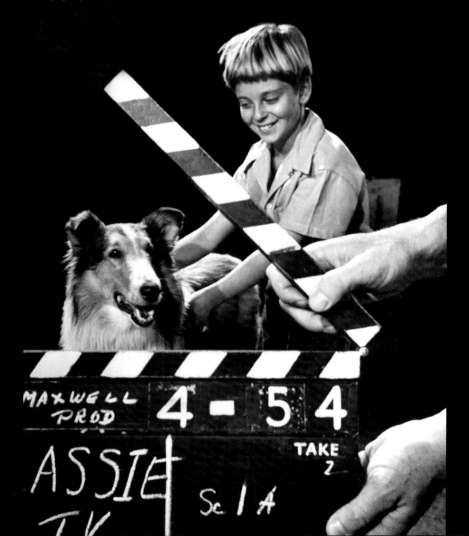

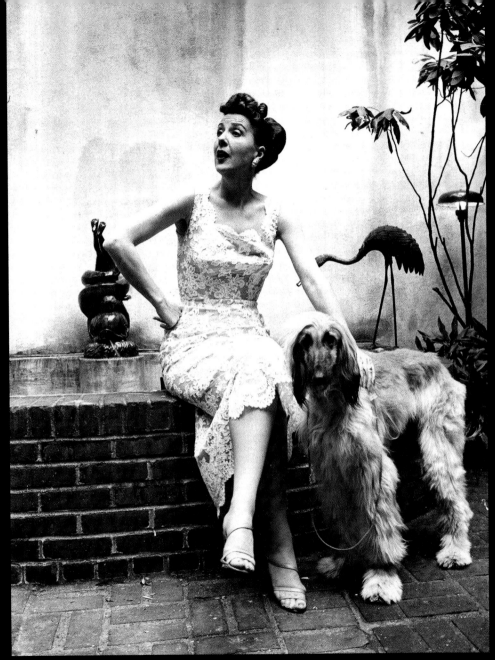

EXOTICS

Entertainer and animal-lover Gypsy Rose Lee and her Afghan Hound,
just one of her many pets, pose for a photo at their Beverly Hills home.
Each has a unique way of commanding our attention.

Photograph by Alfred Eisenstaedt

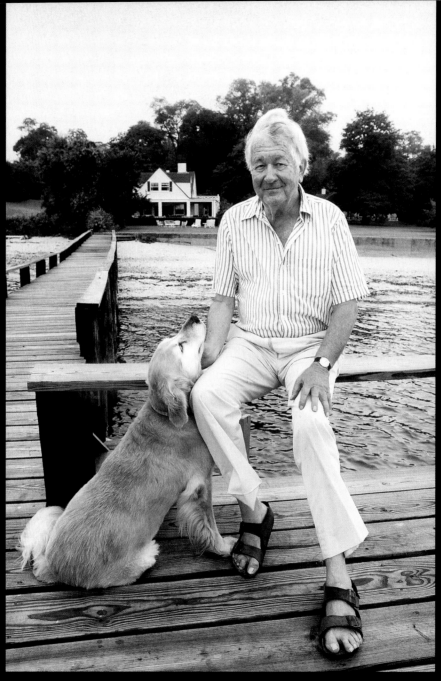

BY THE SEA
William Styron and his Labrador Retriever, Tashmoo, take in the salt air
at his home on Martha's Vineyard.
Photograph by Frederic Reglain

"Our walks are for business and pleasure, and also for survival—interlocking motives that have somehow acquired nearly equal importance in my mind."
— William Styron, American novelist, on walking his dog

THREE HEADS ARE BETTER THAN ONE
Jeff Goldblum and his Rottweiler sun themselves next to a statue in the garden of the actor's Hollywood Hills home.
Photograph by Douglas Kirkland

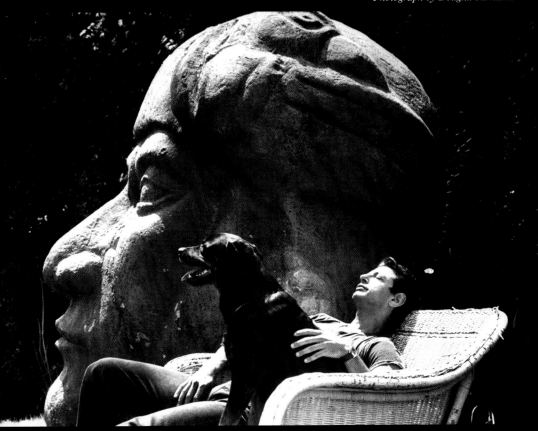

BATH TIME
Nancy Reagan, a dedicated dog person, gamely gives the new White House puppy a bath. Lucky, a Bouvier des Flandres, would eventually retire from Washington to the Reagans' ranch in California.

Photograph by Dirck Halstead

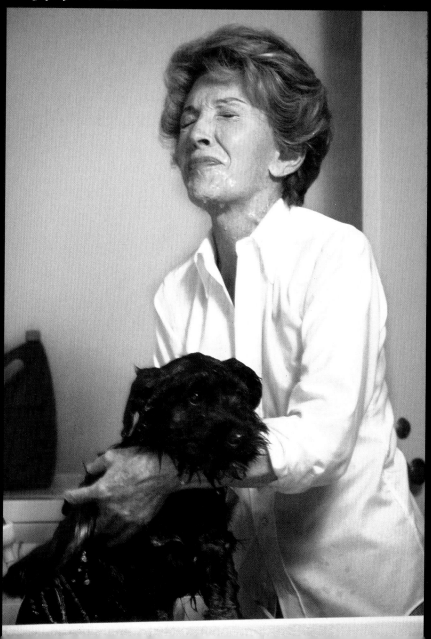

> "She was just a little bundle of fur when I got her, but she grew to be the size of a pony."
>
> — Nancy Reagan, First Lady of the United States

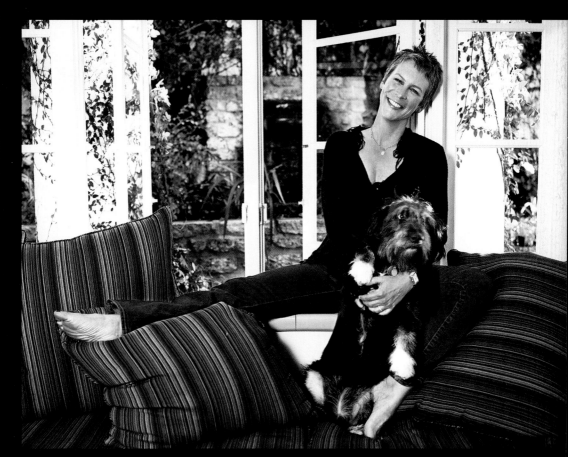

COUCH POTATOES
Actress Jamie Lee Curtis lounges in her Los Angeles home with Frances, a mixed breed dog she adopted from the North Texas Humane Society.
Photograph by Marc Royce

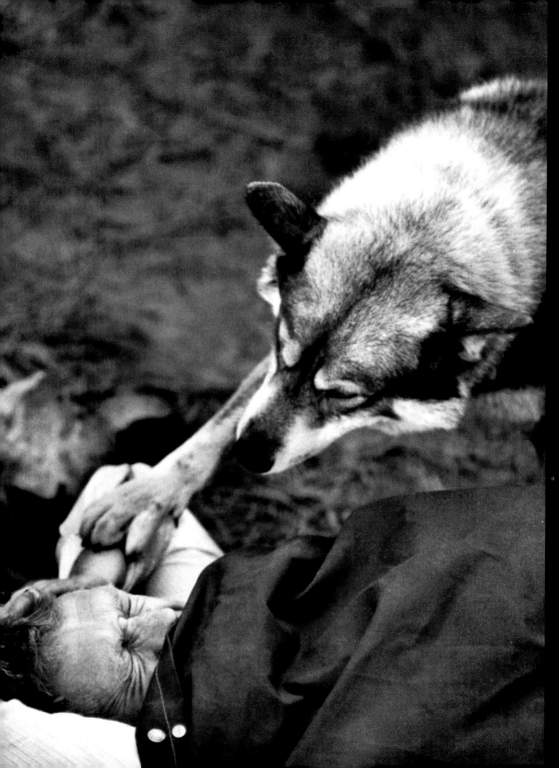

"God is my kids, my old lady, the green grass, trees, machines and animals."

— Steve McQueen, actor

WAKE-UP CALL
A gentle nudge from his Alaskan Malamute makes it certain that McQueen won't be late for a hunting trip in California's Sierra Madre Mountains.
Photograph by John Dominis

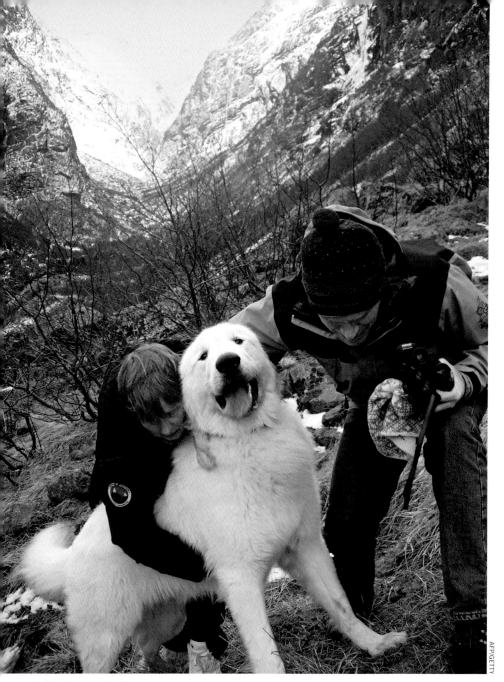

TEARS OF JOY
A Great Pyrenees named Leon is reunited with his owners, Liv and Signe Verhaug, after being stuck on a mountain ledge in Norway's Oldedalen valley for over a week.
Photograph by Inge Faenn

AFP/GETTY

"Dogs have given us their absolute all. We are the center of their universe . . . It is without a doubt the best deal man has ever made."

— Roger Caras, American wildlife writer

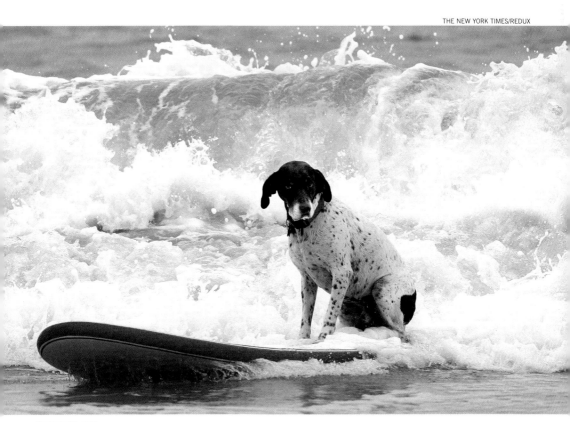

SURF'S UP
Cool doggie dude Murphy, a German Short-haired Pointer, rides a wave at the Loews Coronado Bay Resort in California, proving that canines, too, dream of the endless summer.
Photograph by Sandy Huffaker

> "The hounds all join in glorious cry,
> The huntsman winds his horn:
> And a-hunting we will go."
>
> — Henry Fielding, English novelist

LIBÉREZ LES CHIENS!
No mere pack of dogs, the hounds of Château de Cheverny in France's
Loire Valley invest a lot of pride and dedication in their traditional role
in the château's twice-weekly hunt.
Photograph by Bertrand Rieger

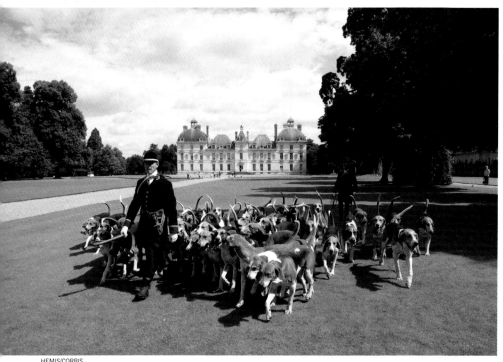

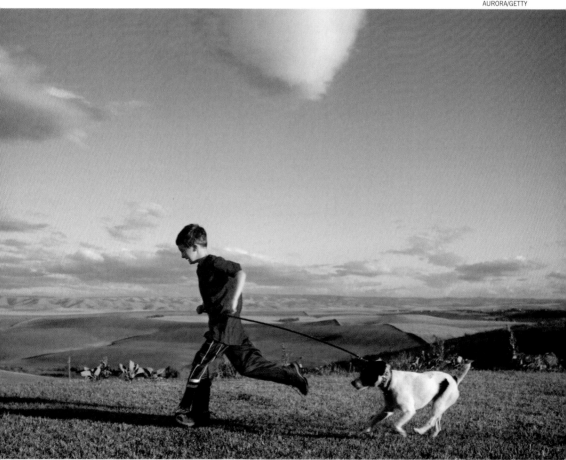

LONG-DISTANCE RUNNERS
Against the backdrop of the Pacific Northwest's big sky,
a young boy leads his Jack Russell Terrier over hill and dale.
Photograph by Chris Butler

"A dog is not 'almost human,' and I know of no greater insult to the canine race than to describe it as such."
— John Holmes, American poet

BEDSIDE MANNER

Chocora, a miniature Dachshund, didn't think twice when given the task of nursing a baby boar back to health after it was abandoned by its mother at the Neo Nature Park in Nago, Japan.

Photograph by Hitoshi Maeshiro

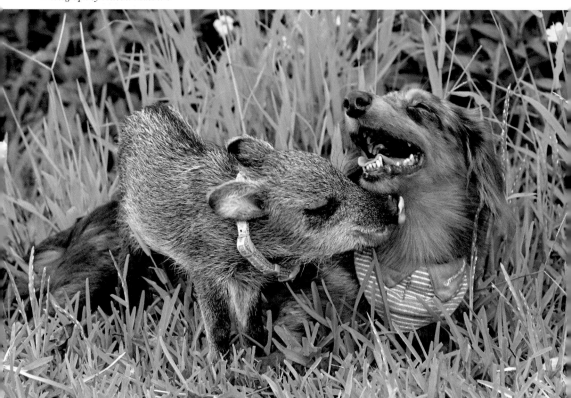

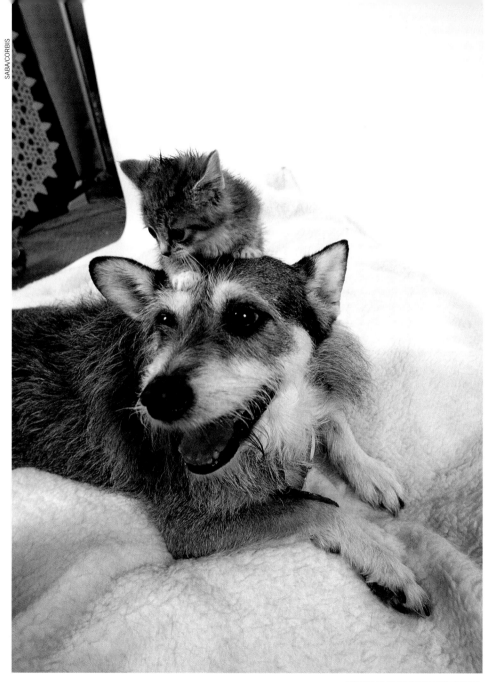

THE CAT WHISPERER
Ginny the rescue dog helps her owner, Philip Gonzalez, find injured and stray cats on
Long Island, New York. Here, she proudly offers a perch to one of her foundlings.
Photograph by Erik Freeland

"Man is a dog's idea of what God should be."
— Holbrook Jackson, English journalist

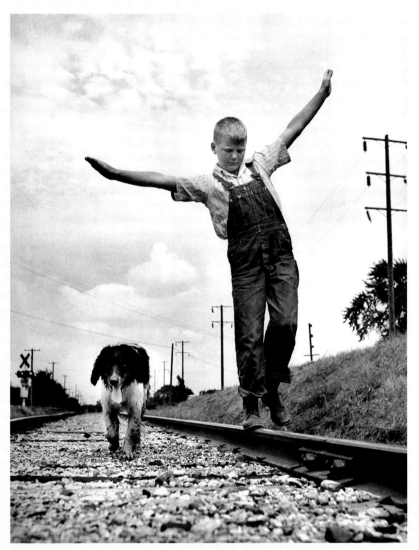

WALKING THE LINE
Twelve-year-old Larry Jim Holm ponders what he and his dog, Dunk,
should do with some free time in Oskaloosa, Iowa.
Photographs by Myron Davis

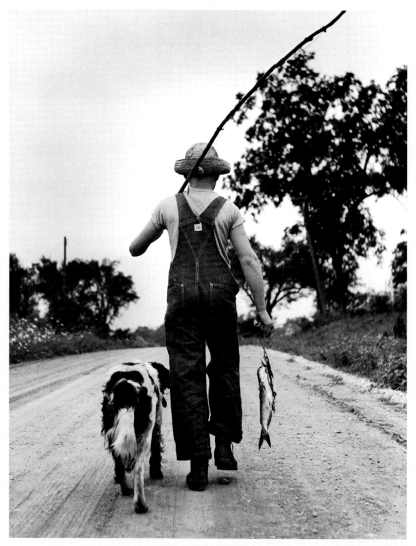

DAY'S END
A mess of fish means that today, instead of walking
the tracks, Larry and Dunk decided to head for the pond.

FLIGHT OF THE BUMBLEBEE
Little Ava may have some questions about why she's dressed up
as a Halloween bee at her Hoboken, New Jersey, home,
but Velcro, her Portuguese Water Dog, is happily abuzz.

Photograph by Mimi Park

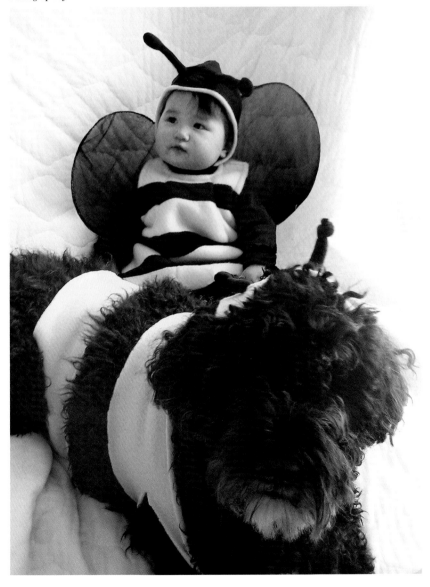

"Bulldogs are adorable, with faces like toads that have been sat on." — William Shakespeare, English playwright

BULLY!
Who doesn't like to smooch a cute baby?
Photograph by Dann Tardif

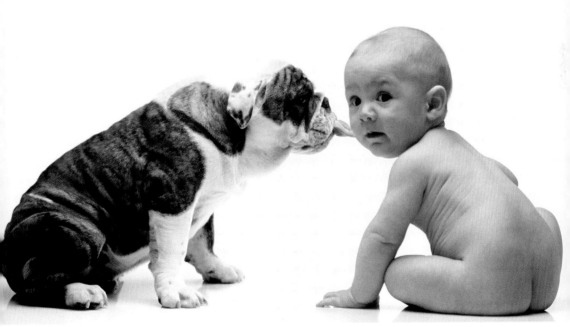

CORBIS

"A house is not a home until it has a dog."
— Gerald Durrell, English zoologist

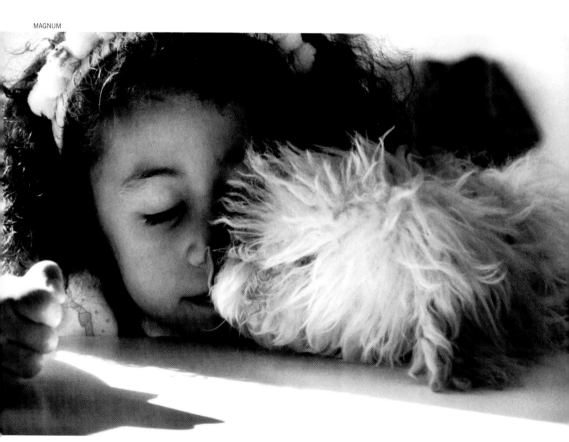

TAKING A MOMENT
A girl and her Poodle commune in Bridgehampton, Long Island.
Photograph by Elliott Erwitt

CUDDLY
A nurturing Labrador won't let anything disturb this little girl's nap.
Photograph by Emma Innocenti

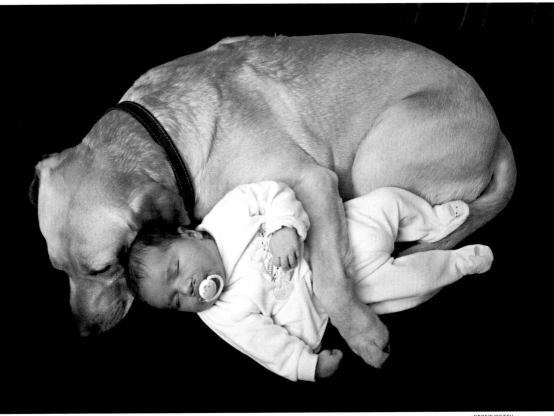

STONE/GETTY

PURE DEVOTION
Kayla's extensive training helps her
assist her human in performing essential
daily activities such as picking up
the keys or answering the phone.
The love comes naturally.
Photograph by Peter McBride

"Acquiring a dog may be the only opportunity a human ever has to choose a relative."
— Mordecai Siegal, American pet author

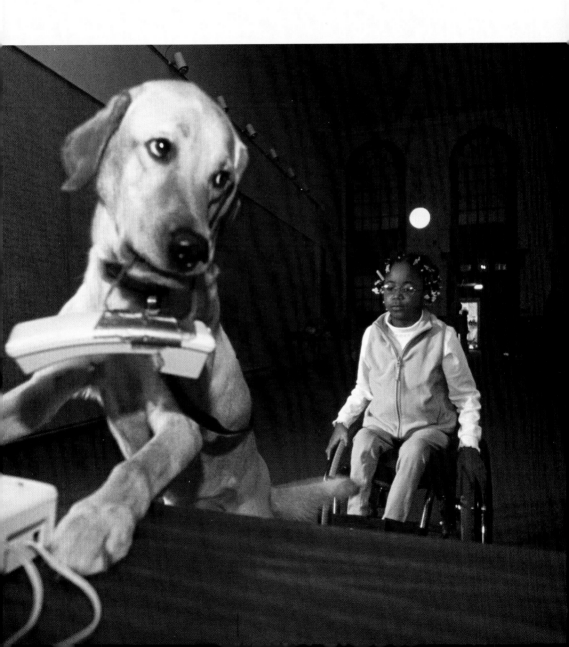

SOMETHING NEW UNDER THE SUN

At 21 ounces, Ulitka, a Petersburg Orchid, is still growing. But topping out at around four pounds, this brand-new breed is claimed to be the world's smallest dog—until next year's model.

Photograph by Alexander Demianchuk

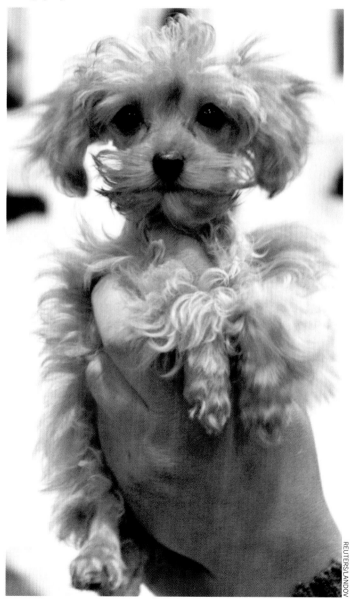

"Dog lovers are a good breed themselves."
— Gladys Taber, American author

NATIONAL GEOGRAPHIC

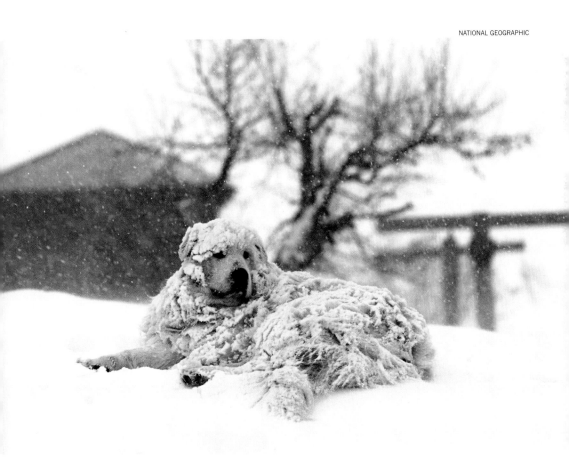

THE SNOW KING
With a coat like this, he may not mind a few flurries—or even a blizzard.
Photograph by William Albert Allard

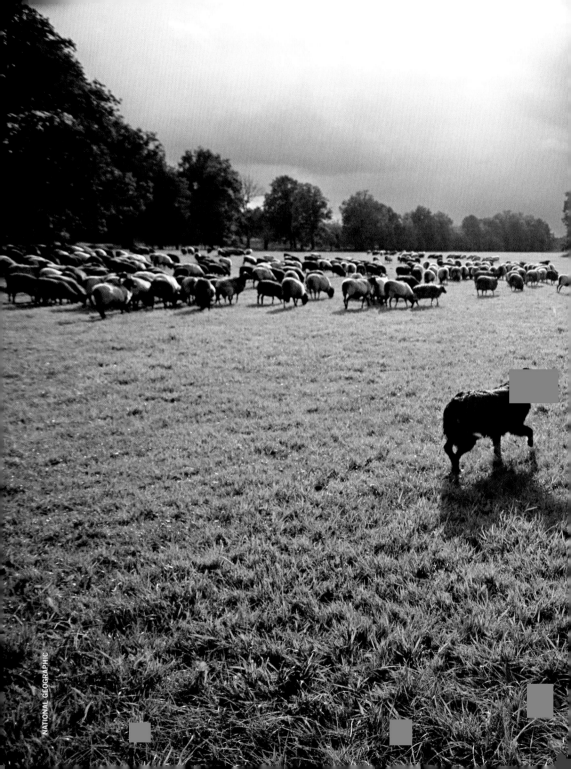

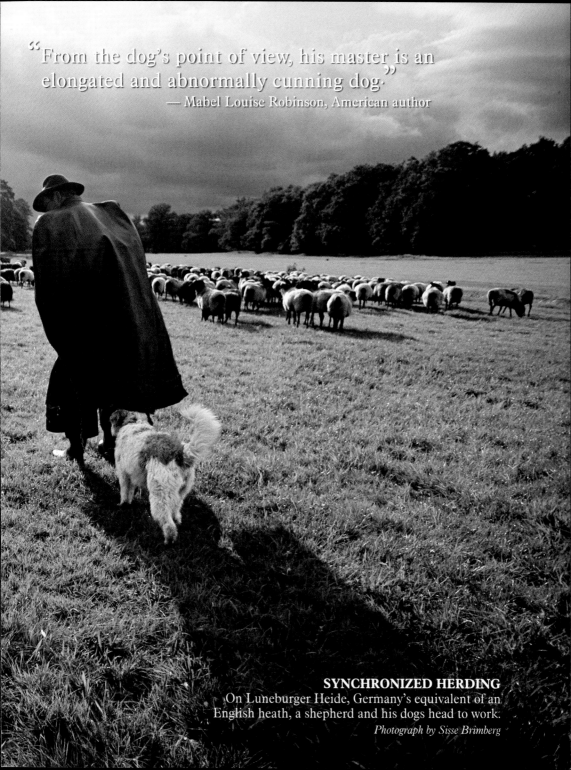

"From the dog's point of view, his master is an elongated and abnormally cunning dog."
— Mabel Louise Robinson, American author

SYNCHRONIZED HERDING
On Luneburger Heide, Germany's equivalent of an English heath, a shepherd and his dogs head to work.
Photograph by Sisse Brimberg

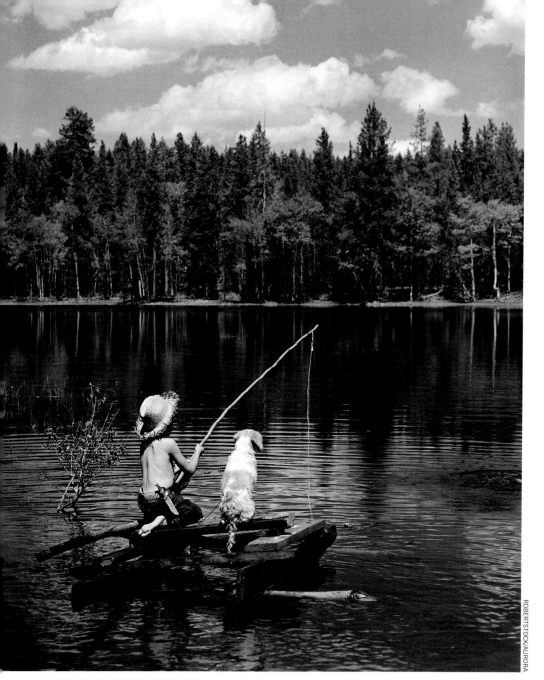

THE COMPLEAT ANGLER
Mighty free and easy and comfortable on a raft,
a Huck Finn look-alike and his dog wait for a nibble.
Photograph by D. Corson

"The more I see of man, the more I like dogs."

— Madame de Staël, Swiss author

IMPERFECTLY BEAUTIFUL
In a world that unfairly sets standards for all creatures great and small, Dalmations without perfect markings, like this forlorn fellow in an English dog rescue center, are often abandoned.
Photograph by Roger Hutchings

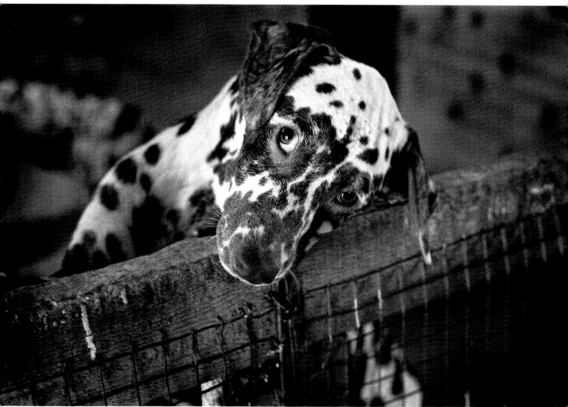

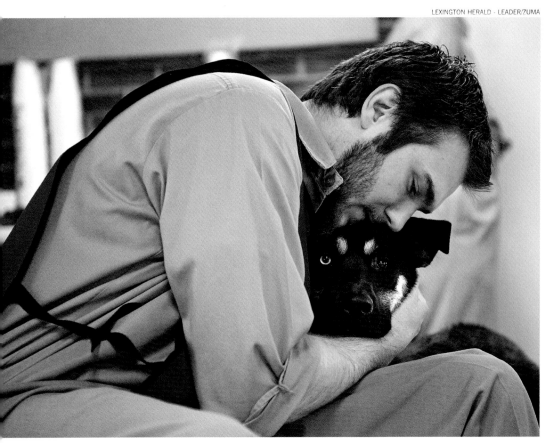

A NECESSARY GOODBYE
Inmate Zack Buda hugs Michael as the pooch graduates from the Canine Companions program at the Blackburn Correctional Complex in Lexington, Kentucky. More trusting of people now, Michael will return to the Humane Society to await adoption while Zack waits out the rest of his sentence.

Photograph by David Stephenson

"It often happens that a man is more humanly related to a cat or a dog than to any human being."
— Henry David Thoreau, American philosopher

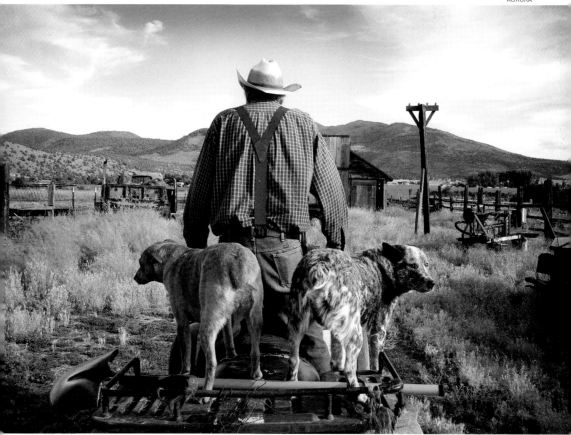

THE OUTDOOR LIFE
Outside of Klamath Falls, Oregon, rancher Lincoln Gabriel and his dogs ride an ATV on the land his father homesteaded in 1909.
Photograph by David McLain

"Old men miss many dogs."

— Steve Allen, American television personality

MORE THAN FRIENDS
Adopting Sydney from the Orphans of the Storm animal rescue center outside of Chicago didn't just save a life. Michael and his wife also added a gentle, loving soul to their family, and it's quite clear that Sydney knows who his dad is.

Photograph by David Sutton

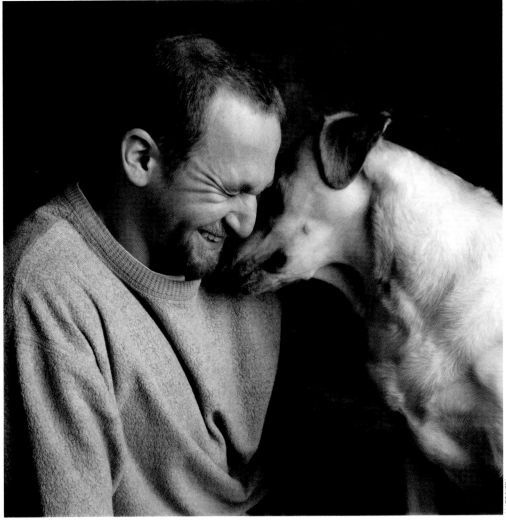

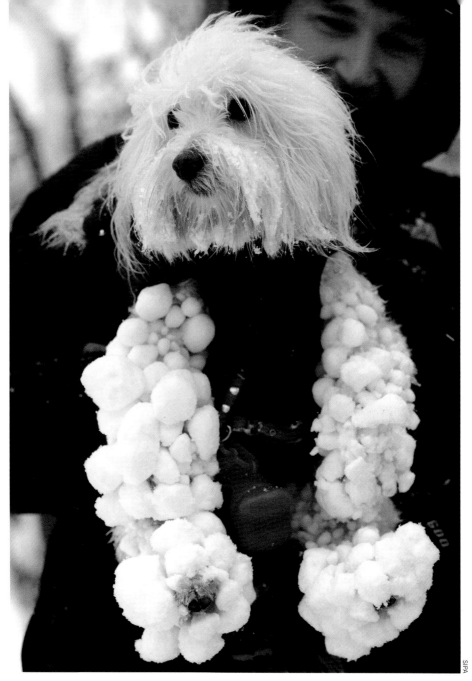

SIPA

GETTING COLD FEET

An unusually heavy snowfall has covered London's Primrose Hill and encrusted the legs of one intrepid pooch with dozens of little snowballs.

Photograph by Hussein Samir

"Spaniels by nature are very loving, surpassing all other creatures, for in heat and cold, wet and dry, day and night, they will not forsake their master."
— Robert Blome, Belgian actor

KITH AND KIN
At 55 pounds, Teddy still considers himself a lapdog and Sarah has no intention of disillusioning her pooch.
Photograph by Christina Lieberman

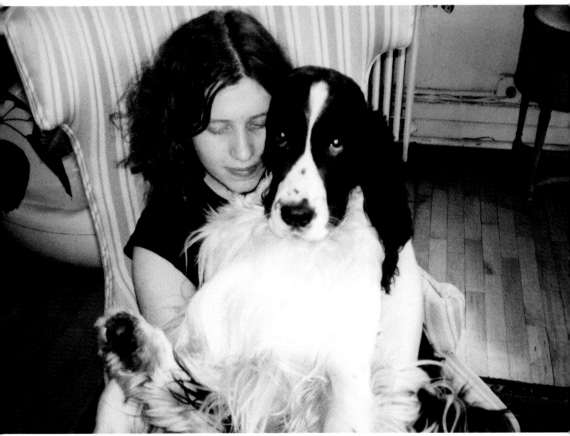

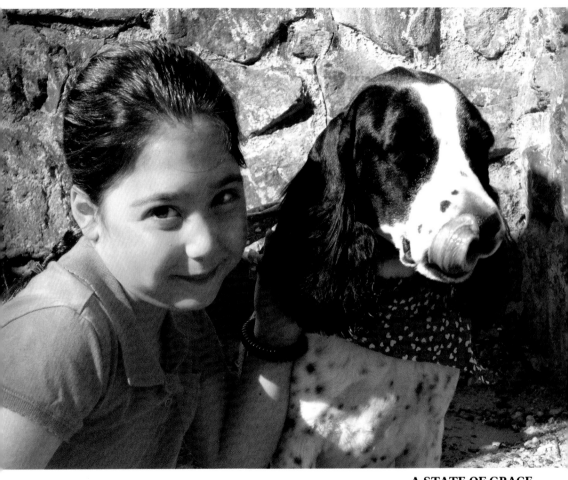

A STATE OF GRACE
Daisy and her human pal, Mary Grace, spend a lot of time together, playing games,
sharing secrets and looking out for each other as best friends should.

Photograph by Wendy Speake

DEEP THOUGHTS
This Labrador puppy clearly has something on his mind.
Photograph by Jorgen Larsson

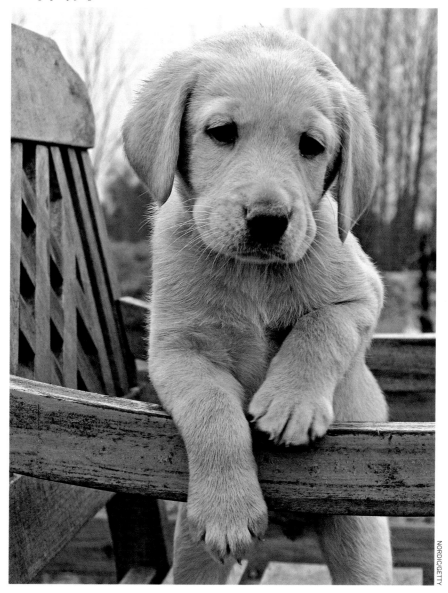

"There is honor in being a dog."

— Aristotle, Greek philosopher

A NOBLE TRADITION

Although rescue work is mostly a thing of the past, Nolane and Zen still spend their summers at the hospice that straddles the top of the Saint Bernard Pass in the Swiss Alps, where several dozen Saint Bernard dogs follow the ancient ways.

Photograph by Olivier Maire

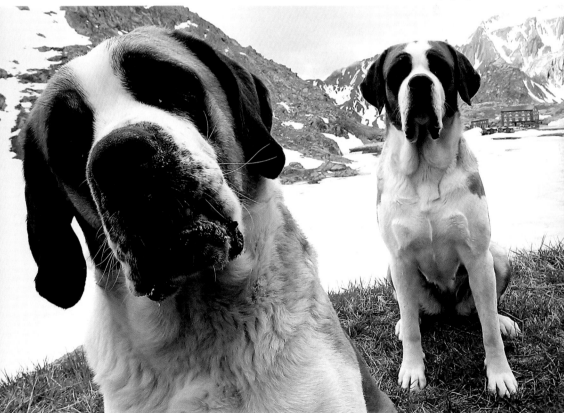

EPA/CORBIS

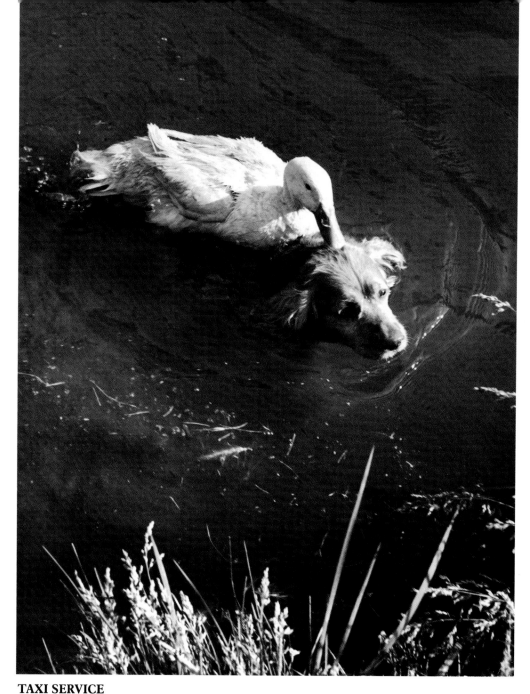

TAXI SERVICE
Donald, a duck with an aversion to water, gets ferried by his Cocker Spaniel friend, Rusty.
Photograph by Loomis Dean

"Dogs can make friends with all kinds of critters—rabbits, cats, birds, bears, fish, even people. It's that last choice that puts their judgment into question." — Anonymous

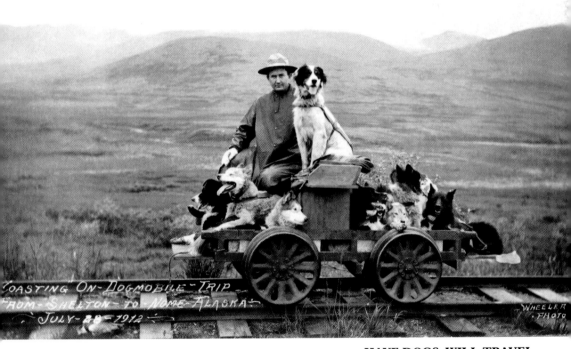

HAVE DOGS, WILL TRAVEL
These lucky dogs enjoy a brief break from their daily toil as they get to ride the rails with their master, coasting through Alaska's rugged Seward Peninsula on a trip from Shelton to Nome.

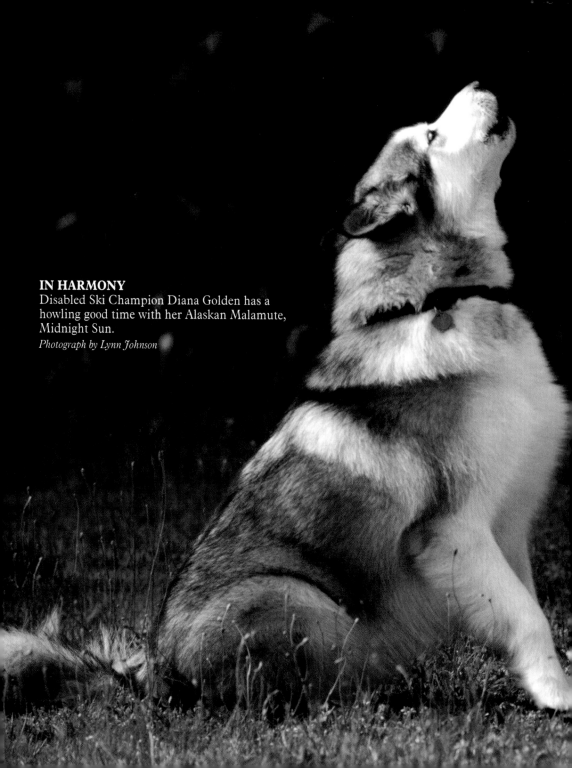

IN HARMONY
Disabled Ski Champion Diana Golden has a
howling good time with her Alaskan Malamute,
Midnight Sun.
Photograph by Lynn Johnson

"When a dog barks at the moon, then it is religion; but
when he barks at strangers, it is patriotism!"
— David Starr Jordan, American ichthyologist

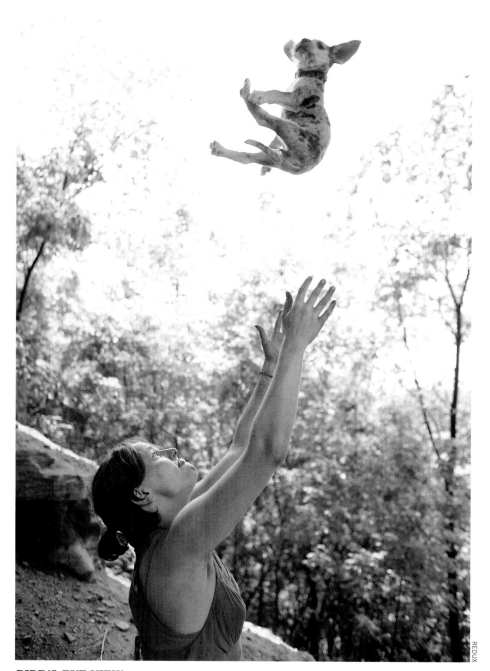

BIRD'S-EYE VIEW
Mallorie's dog, Sepia, is as light as a feather and relishes the occasional toss into the air.
Photograph by James Heil

"The great pleasure of a dog is that you may make a fool of yourself with him and not only will he not scold you, but he will make a fool of himself too."

— Samuel Butler, English satirist

AND THEY'RE OFF!
Lisa Sharkey gives Snoop Dog a shove in the right direction in New York City's Riverside Park during a regional trial of Petco's National Chihuahua Race.
Photograph by Richard Perry

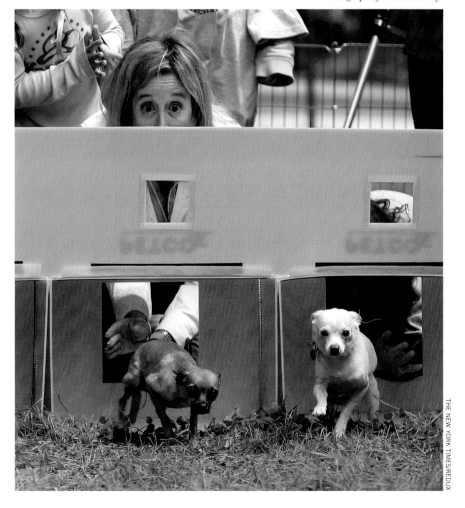

"Yesterday I was a dog. Today I'm a dog. Tomorrow I'll probably still be a dog. Sigh! There's so little hope for advancement."
— Snoopy

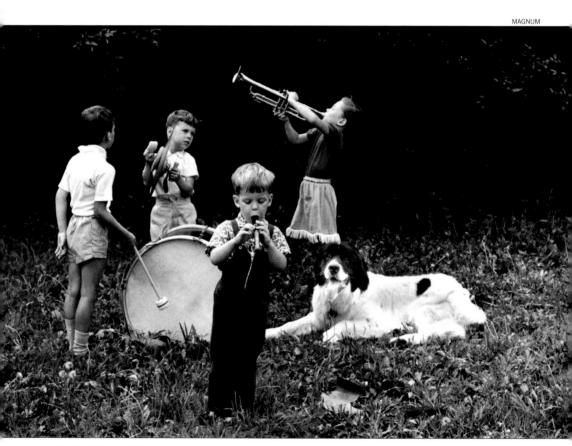

ALL IN THE BAND
A June day in a New York City park is filled with a joyful cacophony as four youngsters tootle, bang and clash, and their Spaniel looks contentedly on.
Photograph by Elliott Erwitt

SNAGGLEPUSS
This fine fellow seems to be expressing some dismay
at facing another snowy day in Lincoln, Nebraska.

Photograph by Joel Sartore

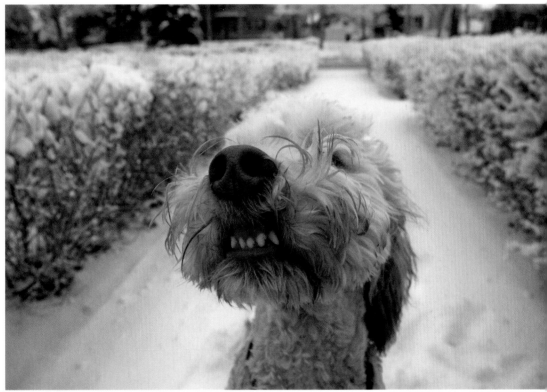

NATIONAL GEOGRAPHIC

> **"**[It's] very important everybody plays the leadership role—the girls, Ms. Michelle, obviously the President. Everybody has to learn to walk the dog, to master the walk.**"**
> — Cesar Millan, the Dog Whisperer

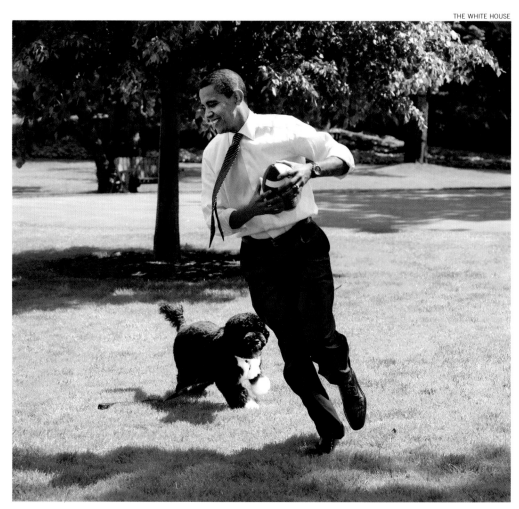

CATCH ME IF YOU CAN
President Obama and his daughters' new dog, Bo,
run through some plays on the White House lawn.
Photograph by Pete Souza

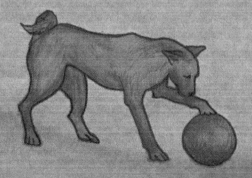

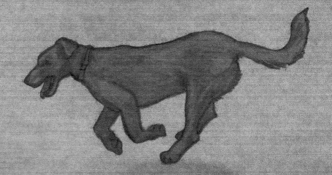